Drawing MOVIE MONSTERS Step-by-Step

Drawing GODZILLA

Greg Roza

WINDMILL BOOKS

New York

Published in 2011 by Windmill Books, LLC
303 Park Avenue South, Suite # 1280, New York, NY 10010-3657

CREDITS:
Edited by: Jennifer Way
Book Design: Julio Gil
Art by Planman, Ltd.

Photo Credits: Cover, pp. 10, 16, 20 Everett Collection; p. 4–5 Shutterstock.com; p. 6 UI/Photofest © United International Pictures; pp. 8,14,18 © TriStar Pictures/courtesy Everett Collection; p. 12 Toho Company/Photofest © Toho Company.

Library of Congress Cataloging-in-Publication Data

Roza, Greg.
 Drawing Godzilla / by Greg Roza.
 p. cm. — (Drawing movie monsters step-by-step)
 Includes index.
 ISBN 978-1-61533-013-3 (library binding) — ISBN 978-1-61533-017-1 (pbk.) —
 ISBN 978-1-61533-018-8 (6-pack)
 1. Monsters in art. 2. Godzilla (Fictitious character) in art. 3. Drawing—Technique. I. Title.
 NC825.M6R69 2011
 700'.47—dc22
 2010004899

Manufactured in the United States of America

For more great fiction and nonfiction, go to www.windmillbooks.com.

CPSIA Compliance Information: Batch #S10W: For further information contact Windmill Books, New York, New York at 1-866-478-0556.

Contents

Look Out, It's Godzilla! 4

Made in Japan 6

A Star Is Born 8

Godzilla Comes to America 10

Fighting Giants 12

Godzilla Suit 14

Godzilla Attacks New York! 16

Final Battle 18

More Than a Movie Star 20

Monster Fun Facts 22

Glossary 23

Read More 23

Index 24

Web Sites 24

Look Out, It's Godzilla!

The sea bubbles off the coast of Japan. A giant dinosaur rises from the water. Buildings fall as the creature crashes its way into the city. Everybody run! It's Godzilla!

PENCIL

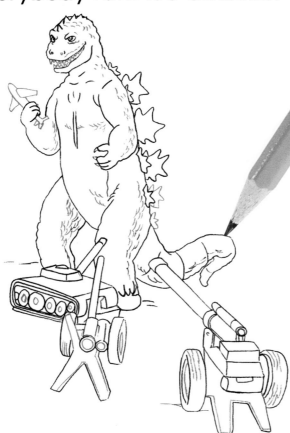

Godzilla caused fear wherever he went, but he wasn't always bad. In fact, in many movies he often helped save the world from other giant monsters. Good or bad, Godzilla has become one of the most memorable movie monsters of all time.

YOU WILL NEED THE FOLLOWING SUPPLIES:

ERASER

PAPER

RULER

COLORED PENCILS

MARKER

Made in Japan

Godzilla was created by Japanese filmmakers. They called the monster "Gojira." The name "Gojira" came from two Japanese words. The first part of the name came from the word *gorira*, which means "gorilla." The second part of the name was *kujira*, which means "whale." English speakers changed the monster's name to Godzilla.

In Japan, Godzilla movies were part of a trend called *daikaiju eiga* (dy-KEE-joo EGG-uh), which means "giant monster movies." Godzilla became the most popular star of these movies.

That's one big monster! Let's start by drawing Godzilla as he attacks a military base.

STEP 1

Draw two shapes for the head and the outline of the body.

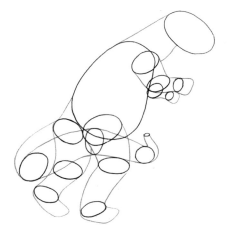

STEP 2

Add a cluster of small circles and ovals around the body.

STEP 3

Draw lines to join the head to the body. Draw the shoulders and arms by joining the top ovals. Join the lower ovals to make the legs and the tail.

STEP 4

Add the mouth outline. Draw hands and feet.

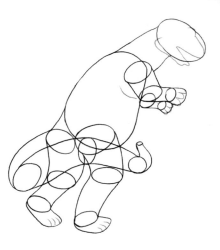

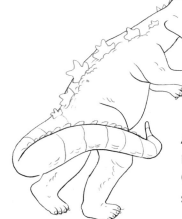

STEP 5

Add eyes, claws, scales, a nostril, and the plates on Godzilla's back. Erase the small circles and ovals.

STEP 6

Add details and color your drawing.

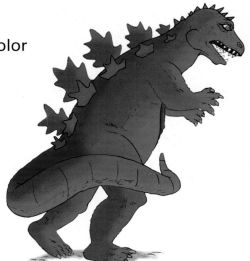

The first Godzilla movie was **released** in 1954. It was called *Gojira*. The movie begins with reports of ships sinking at sea. During a storm, villagers hear screeching, and a house is destroyed. After the storm, scientists find a giant footprint!

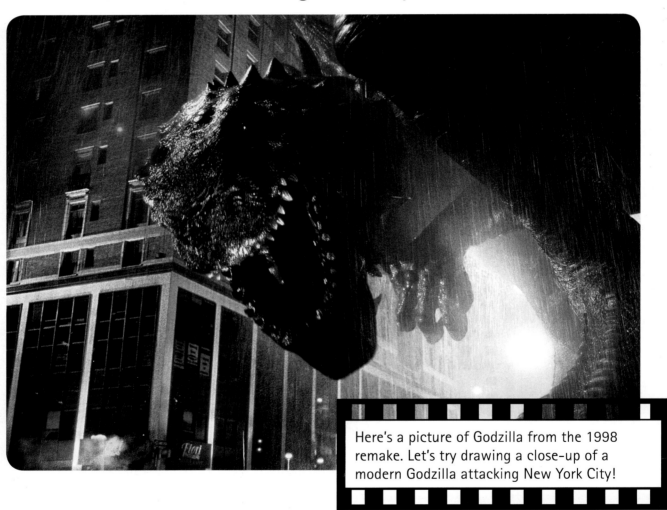

Here's a picture of Godzilla from the 1998 remake. Let's try drawing a close-up of a modern Godzilla attacking New York City!

Later in the movie, Godzilla destroys a city. The monster breathes fire, smashes bridges, and breaks power lines. In the end, only a new **weapon** can stop the giant monster.

STEP 1
Draw an oval.

STEP 4
Add lines for the eyes and the mouth.

STEP 2
Add a smaller circle below the oval.

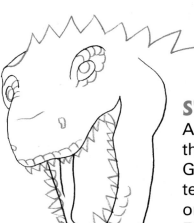

STEP 5
Add details to the eyes. Draw Godzilla's nostrils, teeth, and the plates on top of his head. Erase guide shapes.

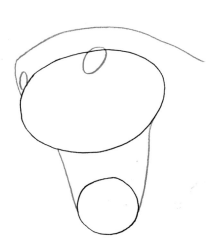

STEP 3
Join the circle and the oval. Add smaller ovals on top of the bigger oval and a guide line for the head.

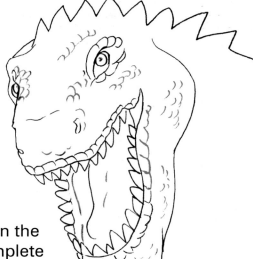

STEP 6
Add scales on the face and complete the facial features.

Godzilla Comes to America

Gojira was a big hit in Japan. In 1956, American filmmakers bought *Gojira* from Japanese filmmakers. The American filmmakers cut out much of the original film. They filmed new scenes with a Canadian actor. This actor played a reporter covering the Godzilla story. These new scenes helped explain the movie's action without having to re-record the Japanese actors' voices.

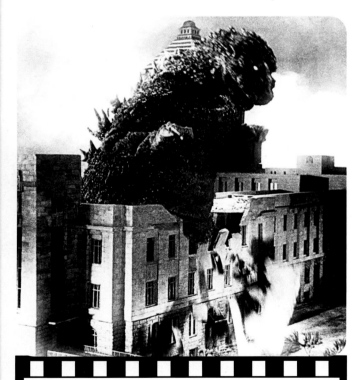

The American filmmakers renamed the movie *Godzilla: King of the Monsters*. The American movie helped make Godzilla popular all over the world.

Godzilla is known for smashing buildings. Shown here in the movie *Gojira*, the monster is walking through a government building in Tokyo.

STEP 1
Draw an oval for the head. Draw the outline of the body.

STEP 2
Add three small ovals on the top left corner of the body outline.

STEP 3
Join the small ovals to make the right arm. Add Godzilla's left arm and the outline of the building in the background.

STEP 4
Add details to the buildings. Draw details on Godzilla's face and hands.

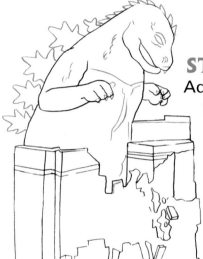

STEP 5
Add the eyes, nose, scales, and claws. Draw the plates along the monster's back. Erase extra lines.

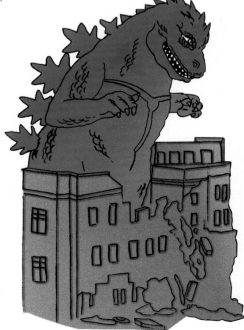

STEP 6
Add details to Godzilla's face and body. Add the windows and the final details to the building. Add color.

Fighting Giants

Japanese filmmakers made many more *Gojira* movies. Godzilla changed over the years. In many movies, Godzilla is the hero that saves the people of Japan. Godzilla is often shown battling other giant monsters.

These monsters include a moth, a shrimp, a three-headed dragon, and even a robot Godzilla!

Godzilla has even fought other famous movie monsters. In 1962, he faced off against King Kong, in the movie *King Kong vs. Godzilla*. The movie also includes a giant octopus!

Let's try drawing Godzilla from the movie *Godzilla vs. the Sea Monster.*

STEP 1

Draw a small oval for the head. Add a shape for the body outline.

STEP 2

Add small circles and ovals all around the body outline.

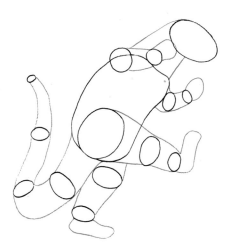

STEP 3

Join the circles and ovals to create arms, legs, hands, feet, and tail.

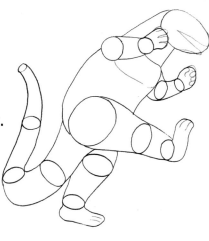

STEP 4

Draw the mouth, hands, feet, and chest.

STEP 5

Add the eyes, claws, spikes, and scales. Erase the guides.

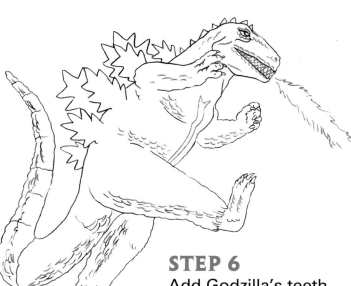

STEP 6

Add Godzilla's teeth. Add details to his body and fire shooting out of his mouth.

Godzilla Suit

People today may not find the original Godzilla scary. But back in the 1950s, people thought Godzilla was really scary and lifelike!

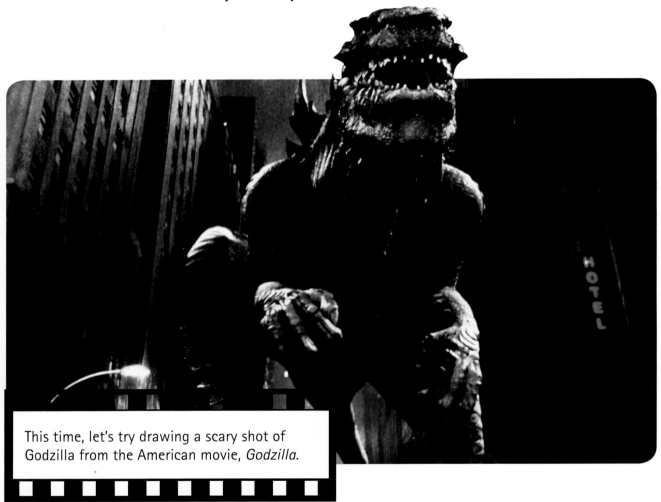

This time, let's try drawing a scary shot of Godzilla from the American movie, *Godzilla*.

How did the films bring the monster to life? Godzilla was played by an actor wearing a rubber suit. Sometimes the actor had to be lifted by wires to make it look like Godzilla was flying. Filmmakers built **miniature** cities for Godzilla to smash. These tiny cities made Godzilla look like he was hundreds of feet tall!

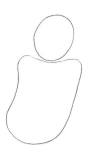

STEP 1

Draw a circular shape for the head. Add the body outline.

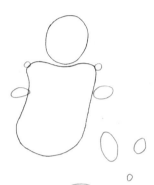

STEP 2

Add small circles and ovals around the body.

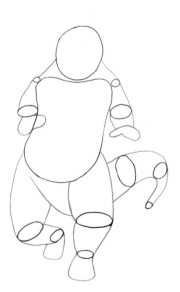

STEP 3

Connect the ovals and circles to make the arms, legs, hands, feet, and tail.

STEP 4

Draw an outline around the face. Add lines to the hands and feet.

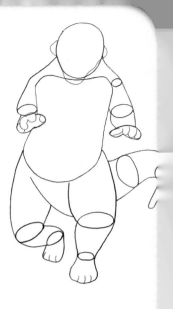

STEP 5

Add Godzilla's eyes, nose, mouth, chest, claws, and scales. Erase the guide shapes.

STEP 6

Add scales and final details to the face.

Godzilla Attacks New York!

In 1998, American filmmakers made a modern Godzilla movie called *Godzilla*. In the movie, the monster attacks New York City. The U.S. military fights back with all of its weapons.

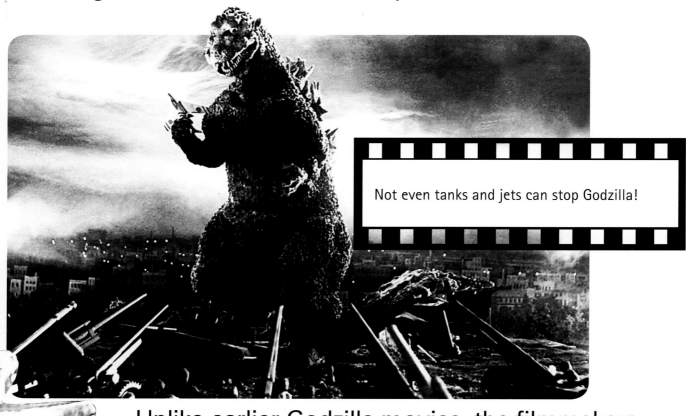

Not even tanks and jets can stop Godzilla!

Unlike earlier Godzilla movies, the filmmakers used computers to create the monster and other **special effects** in *Godzilla*. This allowed the filmmakers to show Godzilla destroying famous New York City buildings. The computer special effects looked more "real" to audiences than the rubber suit and miniature city **techniques** of the older movies.

STEP 1

Draw a circle for the head. Add the outline of the body.

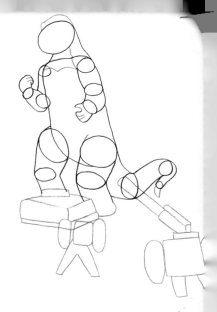

STEP 4

Add lines to the hands to create fingers. Draw a line above the head. Add the outlines of the tanks.

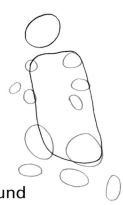

STEP 2

Add circles and ovals around the body.

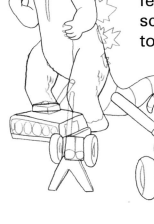

STEP 5

Add the facial features, claws, and scales. Add details to the tanks. Erase extra lines.

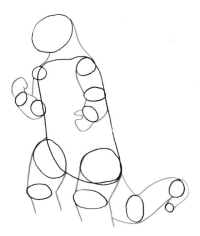

STEP 3

Join the circles and ovals to create the shoulders, arms, hands, legs, feet, and tail.

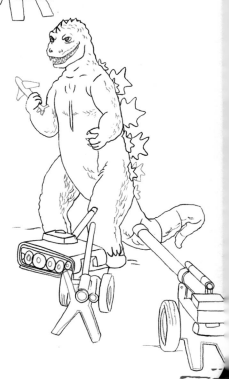

STEP 6

Add details. Draw an airplane in Godzilla's hand.

Final Battle

Since the American movie was released in 1998, Japanese filmmakers have made several new Godzilla movies. Many of Godzilla's old enemies also showed up in these movies.

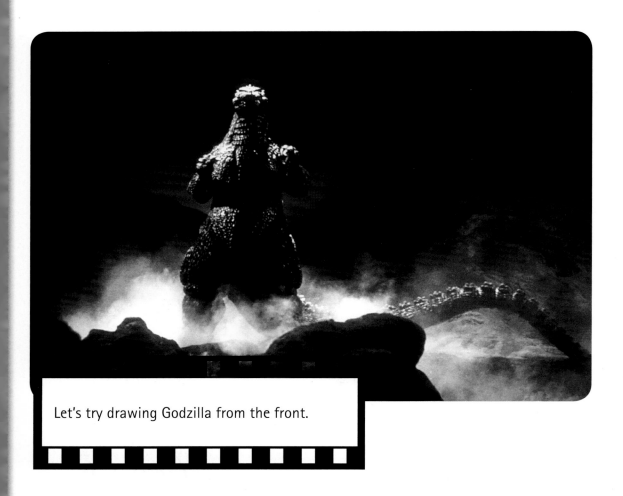

Let's try drawing Godzilla from the front.

In 2004, Japanese filmmakers released *Godzilla: Final Wars*. In *Godzilla: Final Wars*, space **aliens** attack Earth by releasing giant monsters. It's up to Godzilla to save the planet. This is Godzilla's toughest battle yet!

STEP 1

Draw an oval for the face. Add a rounded shape for the body outline.

STEP 2

Add circles and ovals around the body.

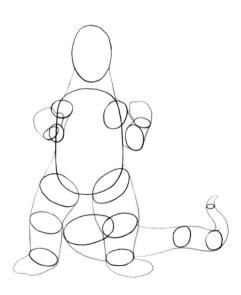

STEP 3

Join the ovals and circles to create the shoulders, arms, legs, hands, feet, and tail.

STEP 4

Add Godzilla's eyes, nostrils, mouth, chest, and claws.

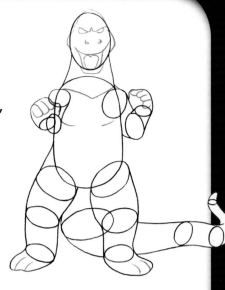

STEP 5

Add details to the face, chest, and hands. Erase the guides.

STEP 6

Finish your drawing by adding details and color.

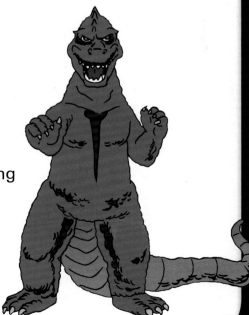

More Than a Movie Star

Godzilla has been in around 30 movies over a span of more than 50 years. This movie monster has had quite a **career**. Godzilla is not just a movie star. The world's most popular monster also appears in comics, cartoons, video games, and television shows. You can even find Godzilla toys.

Godzilla is a hard monster to kill. Fans today still watch the old Godzilla movies. Many eagerly await Godzilla's next adventure.

Now let's draw this memorable picture of the monster eating a train from the movie that started it all, *Gojira*.

STEP 1
Draw a round shape for the head. Add the outline of the body.

STEP 2
Add small ovals and circles around and below the body.

STEP 3
Add lines to connect the ovals and circles. This will finish Godzilla's basic outline.

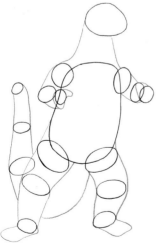

STEP 4
Draw the claws, fingers, and chest. Add rectangles for the train. Draw the tip of the tail and the toes.

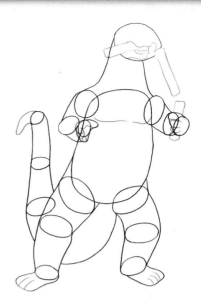

STEP 5
Add the eyes and scales. Draw details on the train. Add the spikes on Godzilla's head. Erase the guide shapes.

STEP 6
Add final details to the face and body.

- The original monster suit used in *Gojira* (1954) weighed about 200 pounds (91 kg). The actor could only walk about 30 feet (9.1 m) at a time.

- The original version of *Gojira* was not released in the United States until 2004.

- No one really knows for sure if Godzilla is male or female.

- Godzilla's son was introduced to fans in the 1967 movie, *The Son of Godzilla*.

- Godzilla first faced the robotic copy of himself in the 1974 movie, *Godzilla vs. Mechagodzilla*.

- Godzilla has a star on the famous Hollywood Walk of Fame!

Glossary

ALIEN (AY-lee-un) A creature from outer space.

CAREER (kuh-REER) A job.

MINIATURE (MIH-nee-uh-chur) A small copy of something larger.

RELEASE (ree-LEES) To make something available to the public.

SPECIAL EFFECTS (SPEH-shul uh-FEKTS) Tricks in moviemaking that make scenes that are fake look real.

TECHNIQUES (tek-NEEKS) A way of doing something.

WEAPON (WEH-pun) Objects used to hurt or kill.

Read More

Emberley, Ed. *Ed Emberley's Drawing Book of Halloween*. New York: Little, Brown, 2006.

Greenberger, Robert. *Meet Godzilla*. New York: Rosen Publishing Group, 2005.

Tallerico, Tony. *Monsters: A Step-by-Step Guide for the Aspiring Monster-Maker*. Mineola, NY: Dover Publications, 2010.

Woog, Adam. *Godzilla*. Farmington Hills, MI: KidHaven Press, 2004.

Index

A
America(n)...10, 14, 16, 18

D
daikaiju eiga...6

G
Godzilla...16
Godzilla: Final Wars...18
Godzilla: King of the Monsters...10
Gojira...6, 8, 10, 12, 20, 22

J
Japan...4, 6, 10, 12, 18

K
King Kong...12

N
New York City...8, 16

R
rubber suit...14, 16

W
weapons...8, 16

Web Sites

For Web resources related to the subject of this book, go to: **www.windmillbooks.com/weblinks** and select this book's title.